# SANTA CARVING

*A carving primer for beginning and advanced carvers*

Ron Ransom

Schiffer Publishing Ltd

4880 Lower Valley Road, Atglen, PA 19310 USA

ISBN: 0-88740-107-4
Printed in China

Published by Schiffer Publishing Ltd.
4880 Lower Valley Road
Atglen, PA 19310
Phone: (610) 593-1777; Fax: (610) 593-2002
E-mail: Schifferbk@aol.com
Please visit our web site catalog at
**www.schifferbooks.com**

This book may be purchased from the publisher.
Include $3.95 for shipping. Please try your bookstore first.
We are interested in hearing from authors
with book ideas on related subjects.
You may write for a free printed catalog.

In Europe, Schiffer books are distributed by
Bushwood Books
6 Marksbury Avenue
Kew Gardens
Surrey TW9 4JF England
Phone: 44 (0)181 392-8585; Fax: 44 (0)181 392-9876
E-mail: Bushwd@aol.com

## DEDICATION

To my wife, Evelyn, who inspires me daily and doesn't fuss too much about wood chips, and to my three grandchildren, Meredith, Ronnie and Tyler who keep the spirit of Christmas in my heart all year long.

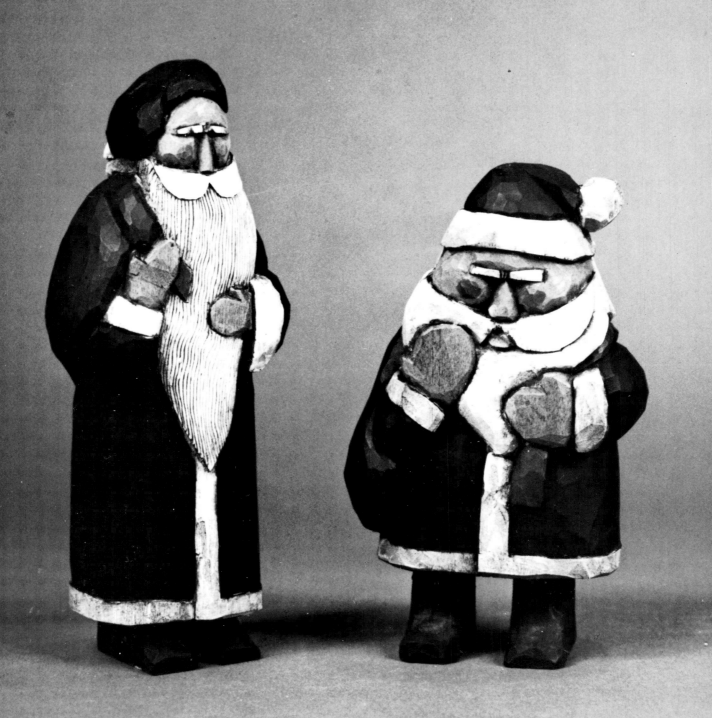

# *Foreword*

There has been a revival in wood carving in recent years. It has become more than just a fine craft; for some it has developed as an art form with all the potential for expressive, artistic exploration and growth.

The author introduces an individualized approach to wood carving. He has chosen the universally recognizable image of SANTA CLAUS to illustrate his perceptions and carving techniques.

The illustrations are offered not to be copied, but to serve as an impetus for the reader to approach his own work with freedom, experimentation and originality; to develop his individual ideas.

From the beginning of time, man has expressed visually using the fundamentals of line, shape, texture, value and color. In an age with a proliferation of technical marvels in art and industry, it is reassuring that an individual continues to use these fundamentals and works quietly in a less than glamorous medium.

To know Ron Ransom is to understand why he responded to the persuasions of his friends and unselfishly agreed to write this illuminating book. It is characteristic of him to document his achievements and share them with others. We will be eternally grateful to Ron Ransom for sharing his art and for creating his SANTAS which are symbolic of all that is good; a constant reminder of things eternal. Perhaps this is more clearly stated in the excerpt from an 1897 editorial in the New York Sun:

> "Yes, Virginia, there is a Santa Claus. He exists as certainly as love and generosity and devotion exist, and you know that they abound and give to your life its highest beauty and joy. Alas! How dreary would the world be if there were no Santa Claus."

Barbara A. Shaw, Ed.D.
Supervisor, Visual Art
Cobb County Public Schools
Marietta, Georgia

# *Introduction*

Since I joined the brotherhood of wood carvers I've been pleased and somewhat amazed at the way tricks of the trade are shared. I have participated in a great number of craft shows and attended many others. I always search out the carvers and have yet to find one who was not friendly and wanting to talk about his craft.

I started carving semi-seriously about eight years ago. First with plaques, then with shore and song birds and a few figures. Two years ago I met Bill Veasey and became one of his less famous duck carvers.

I have been featured in "Inside Cobb" magazine and in 1986 a counted cross stitch book publisher used my Santas on the cover of their "Back Home Christmas" stitchery book. I have received letters of inquiry from all over the U.S.A. and, thankfully, even a few orders.

I hope this book will give you some ideas on carving a Santa. I call mine old world Santas so that collectors are not confused by the Sundblom (Coca-Cola) Santa.

I've tried to structure the book so that someone without access to a great deal of equipment can still turn out a presentable Santa.

For those of you with Foredom and other power tools, I'm sure you can see ways to do the Santas differently and faster.

Good for you! Improve the designs any way you wish.

My way has worked for me, and whatever your stage of expertise, I know you'll enjoy carving a Santa.

# *History*

The Santa Claus figure, in whatever likeness he assumed, has been synonymous with Christmas for hundreds of years. St. Nicholas, Kris Kringle, Father Christmas or our modern Santa rekindles each year the spirit of giving that began with the three wise men who presented their gifts to the Christ child.

Artists have had great fun painting, drawing, carving and sculpting their ideas of how the figure should look.

One of the legends of St. Nicholas is of an earth-bound gypsy wandering from house to house with his gifts and his band of gnomes.

In England, Santa Claus was a composite. The Victorian English usually referred to the jolly elf as "Father Christmas."

With the Dutch-German protestant reform movement came the idea that the Christ child would be at the center and heart at Christmas. The German word for Christ child is Christkindl which eventually became Kris Kringle. After a number of years the original meaning of the word faded and the image reverted to the image of St. Nicholas.

The Santa who is known and loved by American children came from the pen of Thomas Nast who was a Harper's Weekly cartoonist during the Civil War. He was inspired by Clement Moore's immortal poem "A Visit from St. Nicholas." Mr. Moore's vivid portrayal enabled Nast to give Santa the image we enjoy today, the plump, comfortable, lovable gent with the bag of toys on his back.

Madison Avenue took Thomas Nast's image one step further when in the 1920's Coca-Cola artist Haddon Sundblom created the Santa Claus that appeared in advertising and on billboards all over America.

There are many Santa collectors today; one of the most popular collectibles is the carved figure. I found out by accident several years ago when I carved one for my wife. While I was doing hers I cut out several and took them to the next craft show I worked. They sold as soon as I put them out and since then I have been carving Santas year round.

Santas cross all decorating lines. Whether a person is into country or modern decor, a Santa is at home anywhere during the happy Christmas season.

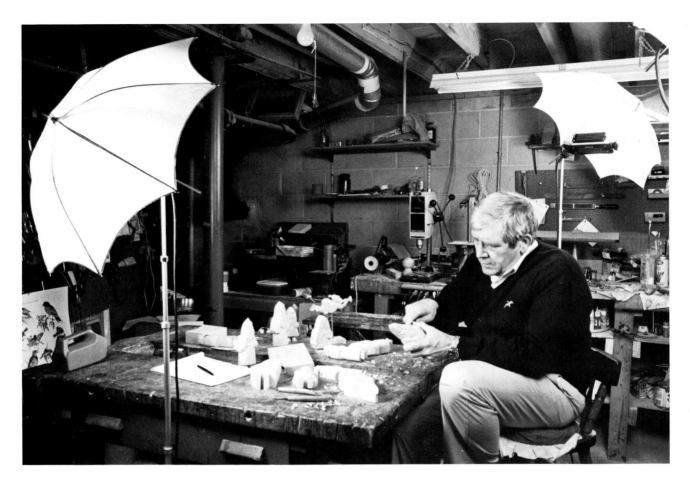

MY WORKSHOP DOESN'T LEAK. THOSE ARE LIGHT REFLECTORS
USED BY MY FRIEND AND PHOTOGRAPHER, GEORGE CLARK.
GEORGE IS DECIDING WHICH LENS TO USE NEXT AND I'M TRYING
TO DECIDE WHAT WOULD HELP ME IF I WERE GETTING READY TO
DO MY FIRST SANTA. I DO KNOW THE MORE YOU CARVE THE
BETTER YOU WILL GET. CARVING IS THE MOST RELAXING THING I
DO. (WELL, ALMOST.) WHETHER YOU ARE DOING ONE SANTA OR
GETTING READY FOR A SPECIAL CRAFT SHOW, I HOPE I'VE HELPED
A LITTLE.

IN THE CLASSES I'VE TAUGHT AT OUR COMMUNITY SCHOOL,
MOST OF THE STUDENTS HAVE BEEN WOMEN. SO LADIES, DON'T
BE INTIMIDATED. I MAY HAVE LEFT SOMETHING OUT OR BEEN
HAZY IN MY INSTRUCTIONS. IF SO, DROP ME A LINE AT BOX 4101,
MARIETTA, GA. 30061. ENCLOSE A S.A.S.E.

GOOD CARVING!

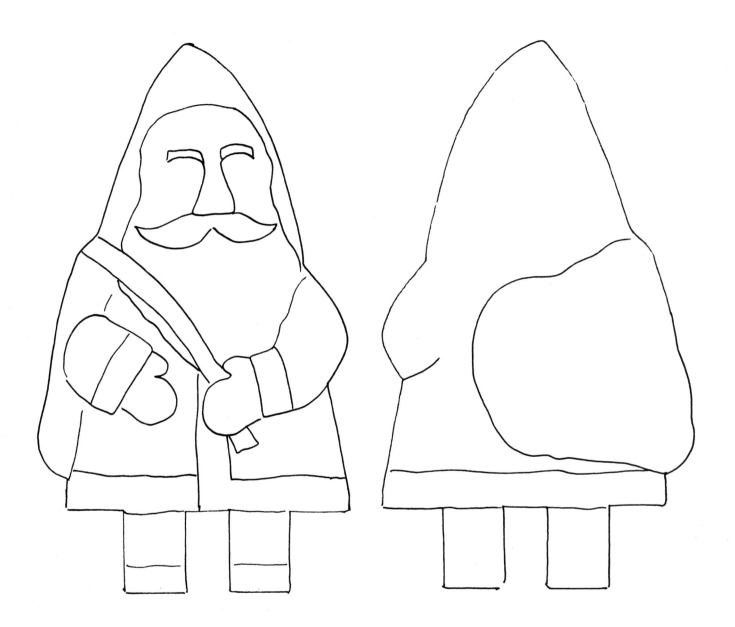

SANTA #1

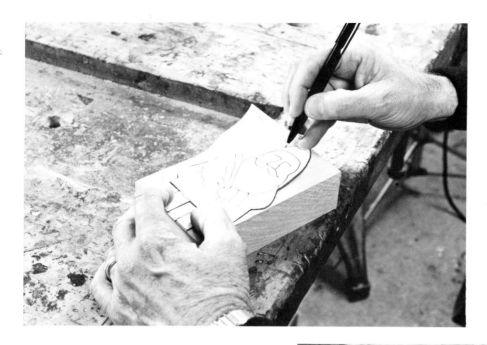

FOR THIS SANTA TRACE THE
PATTERN ON 1¾ INCH PIECE OF
BASSWOOD.
    TRACE SO THAT ONE SIDE OF
THE WOOD IS FLAT. YOU WILL
NEED A FLAT SIDE WHEN YOU CUT
THE FEET.

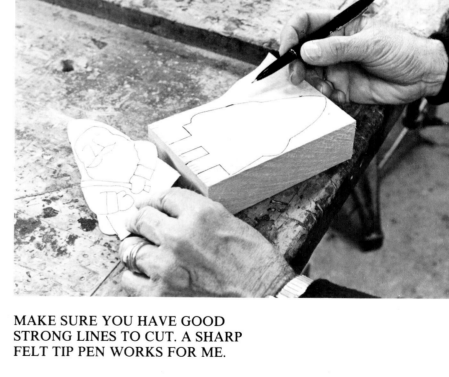

MAKE SURE YOU HAVE GOOD
STRONG LINES TO CUT. A SHARP
FELT TIP PEN WORKS FOR ME.

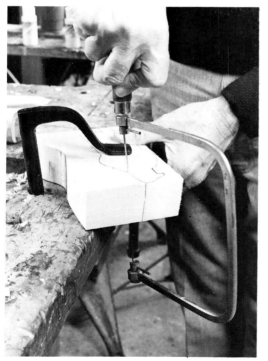

IF YOU DO NOT HAVE ELECTRIC
POWER OR LIKE TO DO PROJECTS
IN A PRIMITIVE MANNER, A COPING
SAW WILL WORK. I KNOW NOW
WHY THEY ARE CALLED COPING
SAWS. I HAD A DIFFICULT TIME
COPING WITH IT.

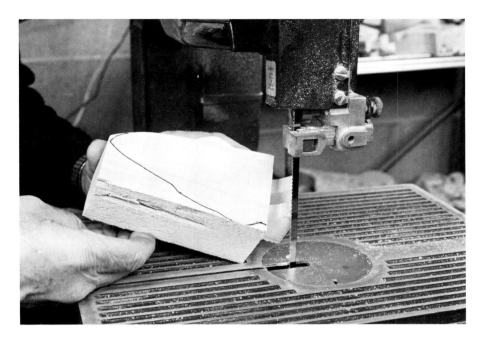

I HOPE YOU HAVE A BAND SAW OR CAN BORROW ONE. I GOT TENNIS ELBOW TRYING TO CUT ONE OF THESE OUT WITH THE COPING SAW.
REMEMBER, LEAVE ONE SIDE FLAT AS YOU CUT. CUT OUT ONE SIDE AND THE FEET.

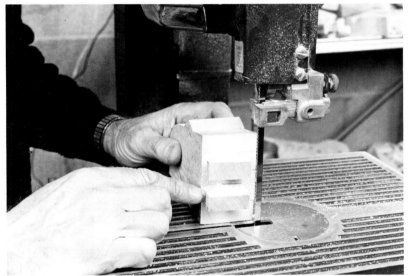

RUN THE GUIDE UP ENOUGH TO GET THE SANTA UNDER. MARK OFF THE FEET, PUT THE FLAT SIDE DOWN AND CUT. AFTER THE FEET ARE CUT RUN THE SAW BACK DOWN (THE GUIDE THAT IS) AND CUT THE REMAINING SIDE.

*CAREFULLY* TRIM THE EDGES OF THE SANTA. THIS IS ONLY TO SAVE A LITTLE TIME GETTING RID OF WASTE AND IS NOT ABSOLUTELY NECESSARY.
TILT THE SAW IF IT'S MORE COMFORTABLE.

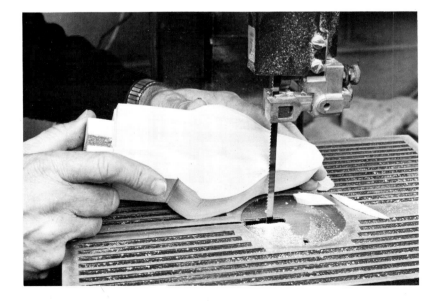

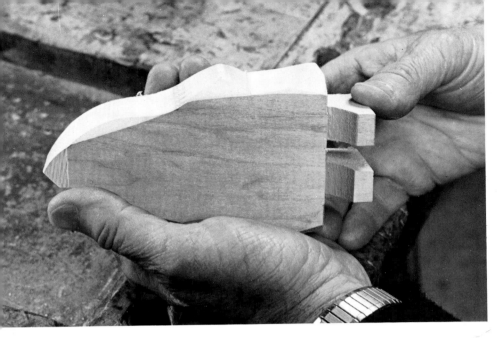

AFTER TRIMMING THE EDGES
YOUR SANTA SHOULD LOOK
SOMETHING LIKE THIS. IF YOU
DIDN'T TRIM THE EDGES DON'T
WORRY ABOUT IT. IT'S NO BIG
DEAL TO DO IT WITH YOUR KNIFE.

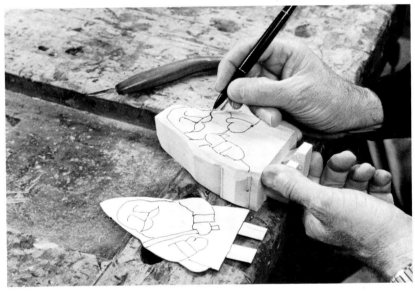

LOOK AT YOUR PATTERN AND
SKETCH THE FACE AND ARMS. I
USED ARTISTIC LICENSE AND
CHANGED THE POSITION OF THE
ARM AND HANDS AND ALSO
WHERE THE BAG STRAP CAME
THROUGH.

TURN YOUR SANTA OVER AND
DRAW HIS BAG.

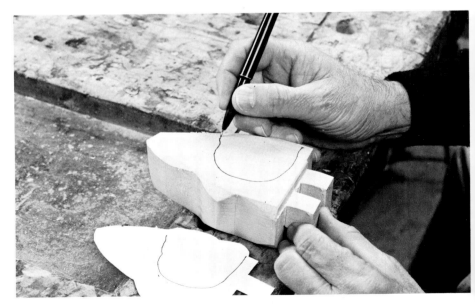

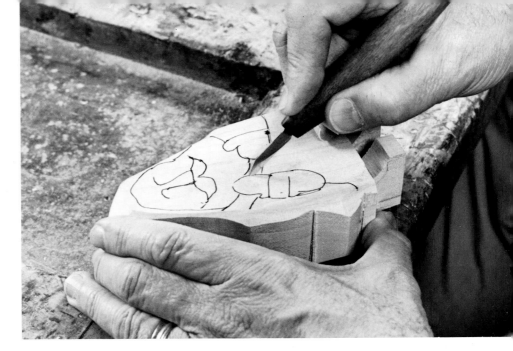

ON A GOOD, FLAT, STEADY
SURFACE START TO INCISE INTO
YOUR LINES ABOUT ⅛ OF AN INCH.
BE SURE YOUR KNIFE IS SHARPEST
AT THIS POINT. YOU WILL NEED A
NICE, SMOOTH CUT. DON'T TRY
THIS IN YOUR LAP.

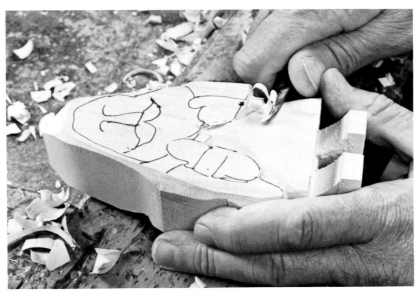

LAYING THE KNIFE ALMOST FLAT,
START CUTTING INTO THE LINE
THAT WAS INCISED. YOU MAY
HAVE TO CUT YOUR LINE A LITTLE
DEEPER. DON'T WORRY ABOUT
GOING TOO DEEP.

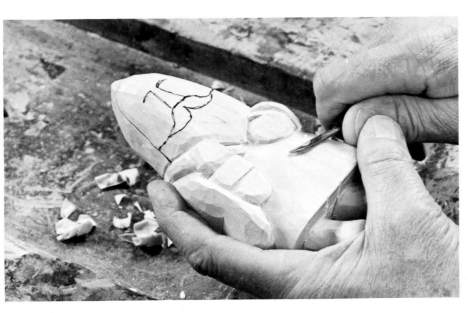

I AM CUTTING AWAY AND
BEGINNING TO ROUND SOME OF
THE EDGES. NOTICE HOW MY LEFT
THUMB PUSHES ON THE RIGHT
THUMB, BOTH FOR CONTROL AND
LEVERAGE.

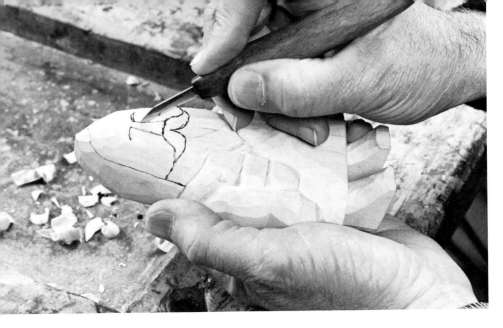

AS YOU ROUND OFF THE CORNERS, INCLUDING THE HEAD AND FACE AREA, YOU WILL PROBABLY HAVE TO DRAW THE FACE AGAIN. YOU MAY WANT TO SHARPEN YOUR POINT NOW. YOU ARE STARTING COSMETIC SURGERY. INCISE THE FACE LINES.

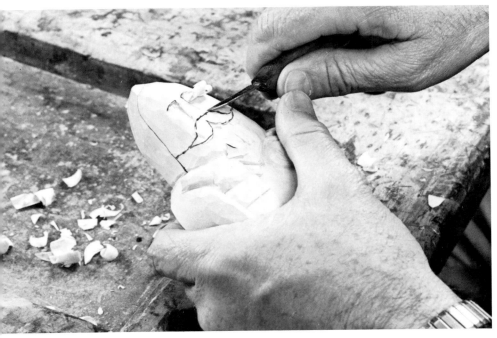

HAVE YOUR WIFE, GIRL FRIEND OR MOTHER BRING YOU YOUR FAVORITE BEVERAGE. THIS IS THE MOST IMPORTANT PHASE OF SANTA CARVING. CUT AWAY FROM THE NOSE AND EYE AREA. THE NOSE SHOULD BE PROMINENT AND NOT FLAT.

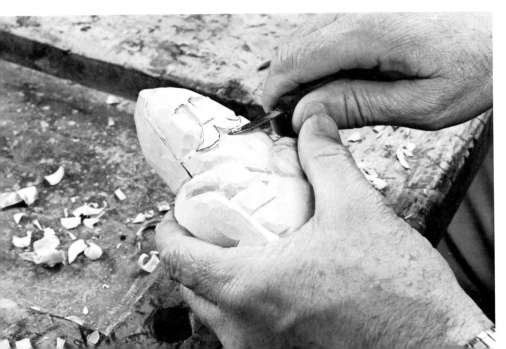

NOW, CAREFULLY TRIM AROUND THE MOUSTACHE AREA. REMEMBER THE THUMB FOR LEVERAGE. GET CLOSER TO THE END OF THE BLADE FOR CONTROL.

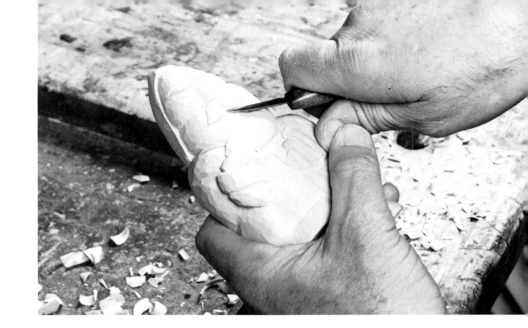

I HAVE ROUNDED THE FACE, DEFINED THE NOSE AND ALSO DEFINED THE HOOD. GUARD AGAINST HAVING THE FACE TOO SQUARE.

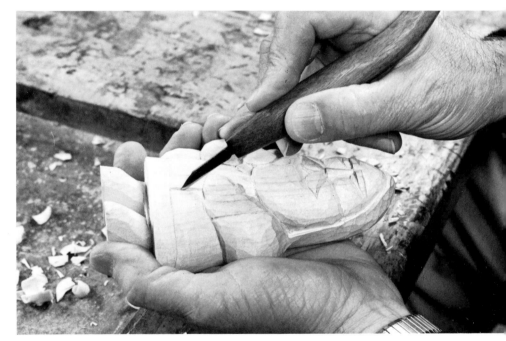

INCISE THE FUR LINES DOWN THE FRONT OF SANTA'S COAT AND AROUND THE BOTTOM COMPLETELY AROUND, INCLUDING THE BACK. THE SLEEVES ALSO HAVE FUR.

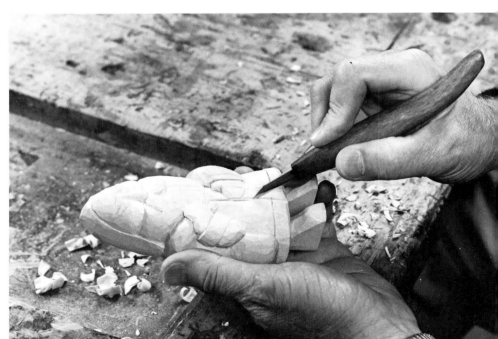

CUT AWAY THE EXCESS. THIS DOESN'T NEED TO BE TOO DEEP. WHEN YOU HAVE PAINTED YOUR SANTA THE WHITE FUR WILL STAND OUT.

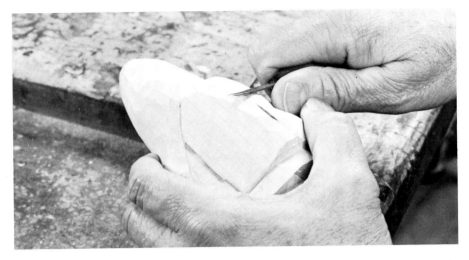

TURN YOUR SANTA OVER AND USING YOUR INCISING KNOWLEDGE, DEFINE THE BAG. IT IS ALSO IMPORTANT HERE TO ROUND THE BAG, PARTICULARLY WHERE IT SHOWS IN FRONT.

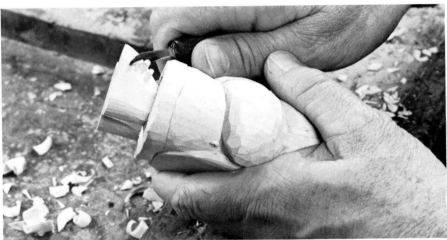

CUT THE EDGES OFF THE BOOTS AND TRIM ANY ROUGH EDGES THE SAW MAY HAVE LEFT. BE GENTLE HERE OR YOU MAY AMPUTATE A LEG.

HERE ARE THE STEPS YOU'VE GONE THROUGH. DON'T WORRY IF YOUR SANTA ISN'T EXACTLY THE SAME. YOU HAVE ADDED YOUR PERSONALITY AND PROBABLY EVEN IMPROVED HIS LOOKS. YOU ARE NOW READY TO PAINT.

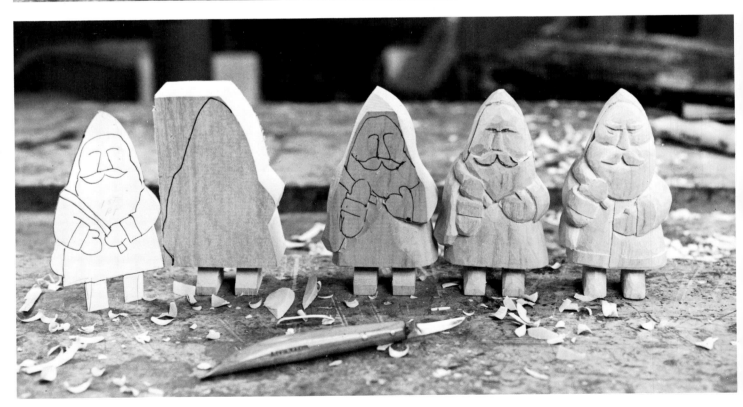

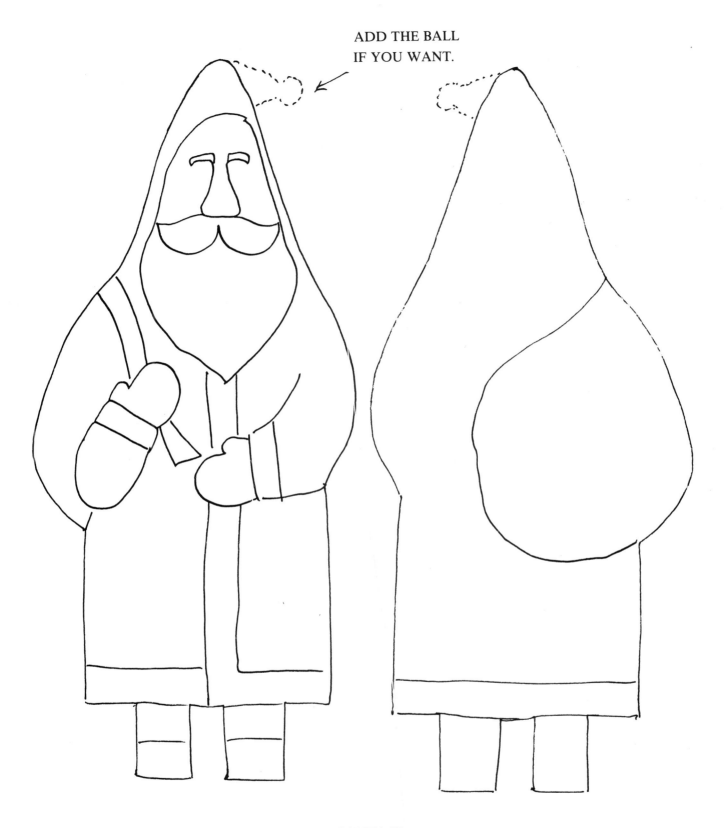

ADD THE BALL
IF YOU WANT.

SANTA #2

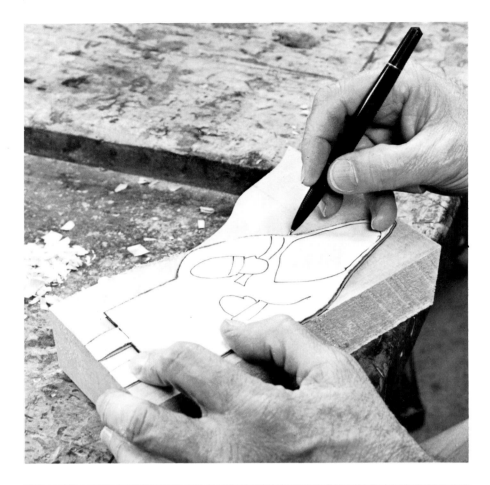

ON THE SANTA #2. TRACE THE
PATTERN ON A PIECE OF 1¾ INCH
BASSWOOD. AGAIN, LEAVE ONE OF
THE NARROW SIDES FLAT TO HELP
WHEN YOU ARE READY TO SAW
THE FEET.

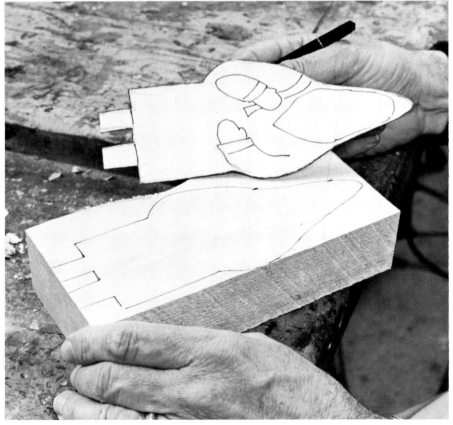

BE SURE YOU HAVE CLEAR LINES.
IF YOU ARE GOING TO ADD THE
BALL ON THE PATTERN, DRAW IT
ON NOW.

YOU CAN SEE THE NARROW SIDE
OF THE FEET AND ONE SIDE OF
THE PATTERN ARE CUT. NOTICE
THE FLAT SIDE. IN THE NEXT
PHOTO YOU CAN SEE WHY THE
FLAT SIDE WAS LEFT.

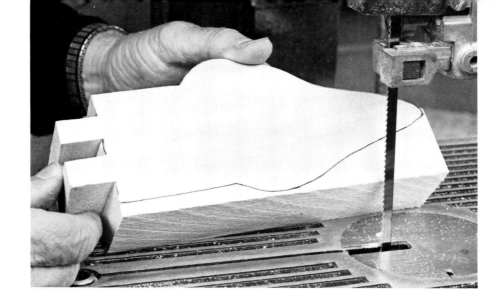

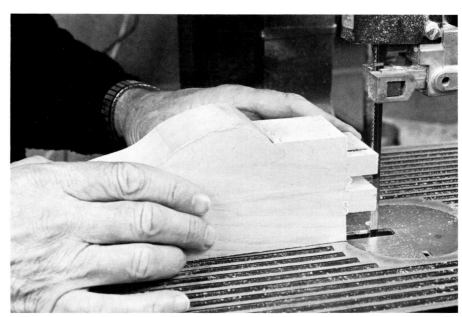

RUN THE GUIDE UP AND CUT OUT
THE FEET.

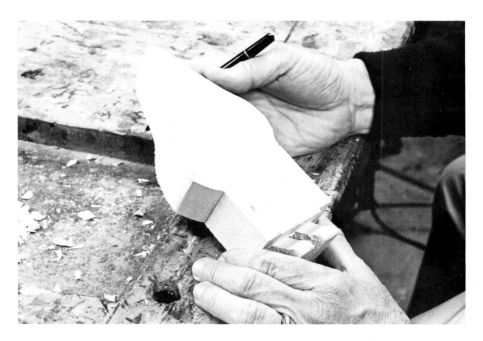

YOUR SANTA SHOULD LOOK
SOMETHING LIKE THIS NOW. YOU
MAY START CARVING NOW OR GO
TO THE NEXT STEP.

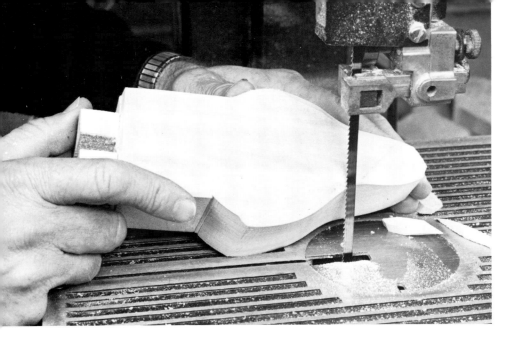

RUN THE SAW GUIDE UP AGAIN AND TRIM THE SHARP EDGES. TILT THE BED IF IT IS EASIER. DO NOT TAKE LARGE PIECES OFF OR THE SAW MAY GRAB YOUR WORK. BE CAREFUL!

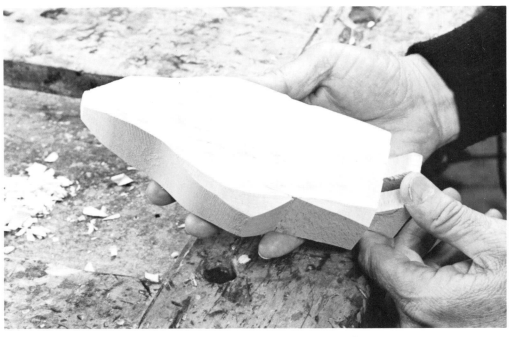

IF YOU TRIMMED THE CORNERS, YOUR SANTA SHOULD LOOK SOMETHING LIKE THIS.

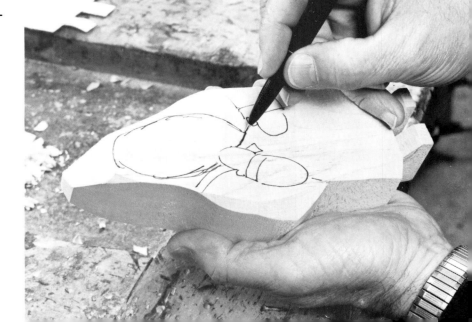

DRAW THE FACE, ARMS AND SACK ON YOUR PIECE OF WOOD.

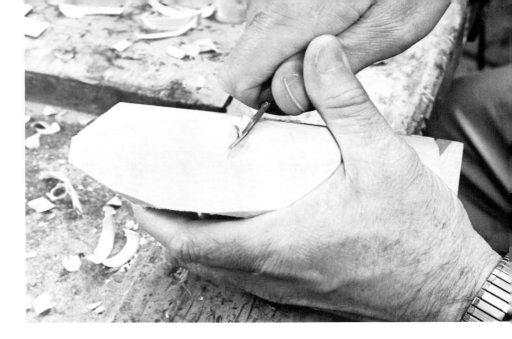

BEGIN ROUNDING THE SANTA.
REMEMBER TO USE YOUR OTHER
THUMB FOR LEVERAGE AND
CONTROL.

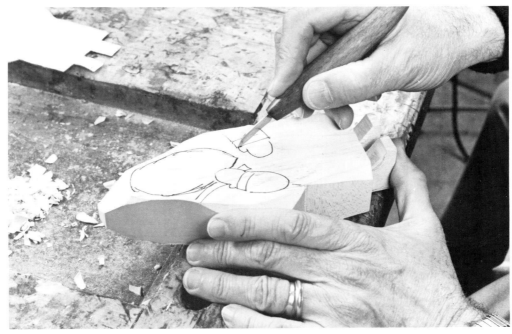

INCISE ALL YOUR LINES ABOUT ⅛
OF AN INCH. YOUR KNIFE POINT
MUST BE SHARP OR YOU WILL GET
FEATHERY AND NOT CRISP
DEFINITION.

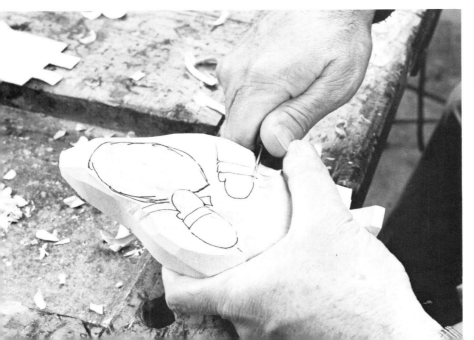

WITH THE BLADE ALMOST FLAT
BEGIN CUTTING TO THE INCISED
LINE. CONTINUE ROUNDING.

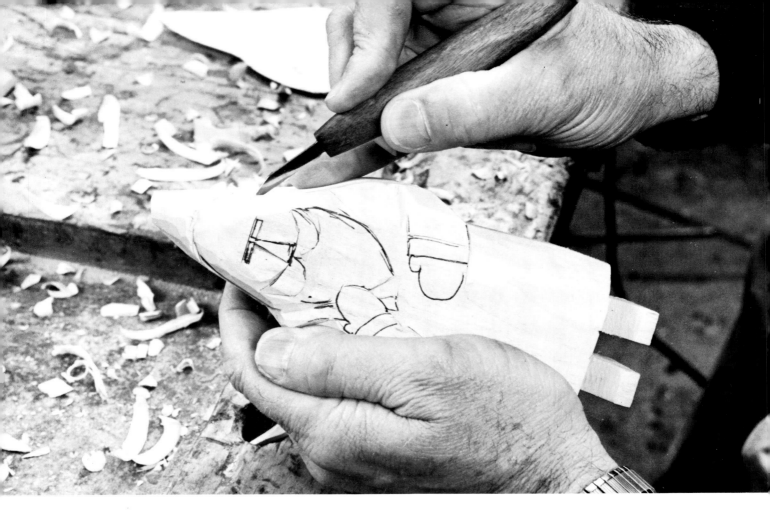

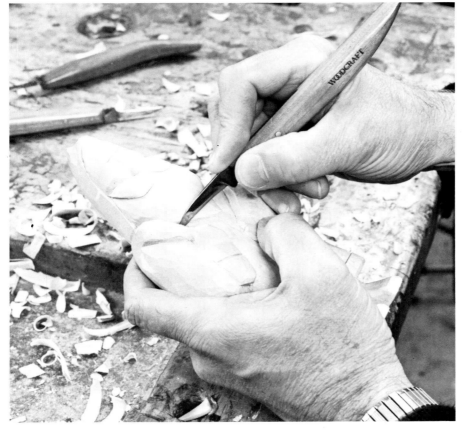

DRAW THE FACE ON IF YOU HAVEN'T DONE SO. INCISE AROUND THE HOOD AND START DEFINING THE FACE.

REMEMBER, IF YOUR FACE IS WELL DONE YOU CAN GET BY ON OTHER AREAS OF YOUR SANTA.

GET GOOD DEFINITION BETWEEN THE BAG STRAP AND BEARD. NOTICE THE NOSE AND MOUSTACHE ARE VERY PROMINENT. THEY ARE PROBABLY THE MOST IMPORTANT FEATURES OF THE FACE.

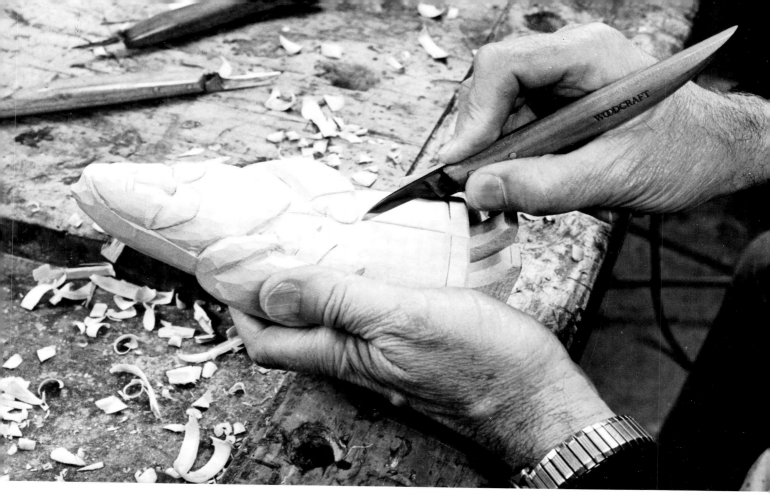

WHEN PAINTED, THE FUR WILL ADD CONTRAST. I HAVE CHANGED KNIVES AND I ALWAYS KEEP SEVERAL SHARP. I DON'T LIKE TO STOP ONCE I GET ON A ROLL.

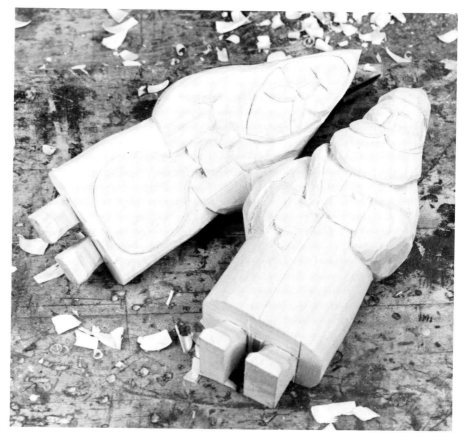

THE SANTA ON THE LEFT IS A GOOD EXAMPLE OF A BAD EXAMPLE. THE FACE AND BEARD ARE TOO FLAT AND HE IS TOO SQUARE. THE WOOD IS TOO NARROW TO BE ABLE TO GET MUCH DETAIL.

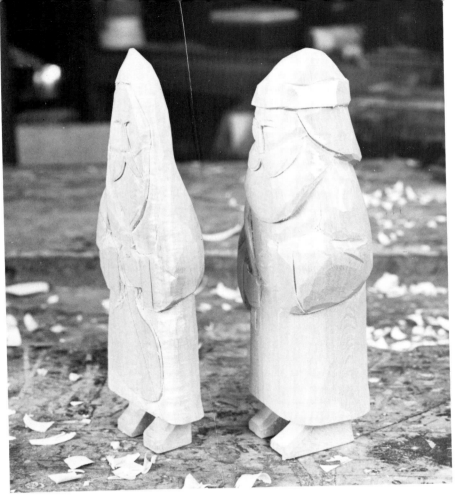

I FEEL THIS PHOTO SHOWS A GOOD EXAMPLE OF THE DIFFERENCE BETWEEN THICK AND THIN WOOD.
   YOU ARE ABLE TO GET BETTER DETAIL WITH THE THICKER WOOD.
   THE THIN PIECE LOOKS TOO MUCH LIKE THE PAINTED WOOD THAT IS RUNNING AMUCK AT CRAFT SHOWS ACROSS THE COUNTRY.

HERE ARE THE STEPS ON SANTA #2. BEFORE PAINTING CHECK THE FOLLOWING:
1. IS HE ROUNDED AND NOT BOXY?
2. IS THE FACE ROUNDED WITH GOOD DEFINITION BETWEEN THE FACE, BEARD AND NOSE?
3. DOES HE LOOK LIKE MY MOTHER-IN-LAW? IF SO, YOU MAY OR MAY NOT WANT TO START OVER.

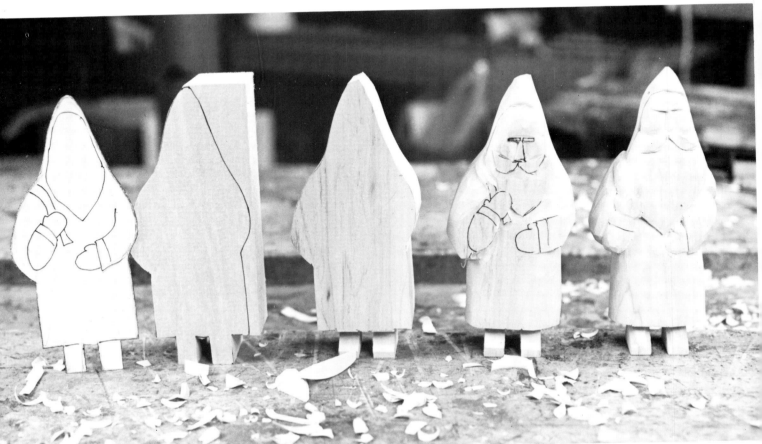

IF YOU HAVE COMPLETED THE
OTHER TWO SANTAS YOU SHOULD
BE FAMILIAR WITH THE BASIC
STEPS. THIS IS THE SANTA I CUT
OUT WITH THE COPING SAW. IT
CAN BE DONE. HOWEVER, I HOPE
YOU WILL HAVE, OR HAVE ACCESS
TO, A BAND SAW.

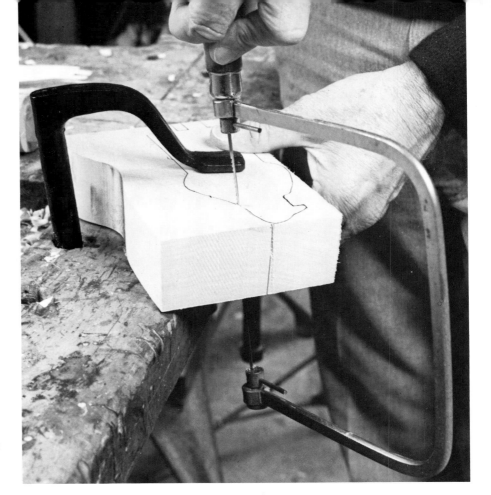

THESE ARE THE STEPS YOU WILL
USE. BEFORE GOING FROM ONE
STEP TO THE NEXT, TAKE A LOOK
AT YOUR OTHER SANTAS. SANTA #3
HAS A LITTLE MORE DETAIL THAN
THE OTHERS.

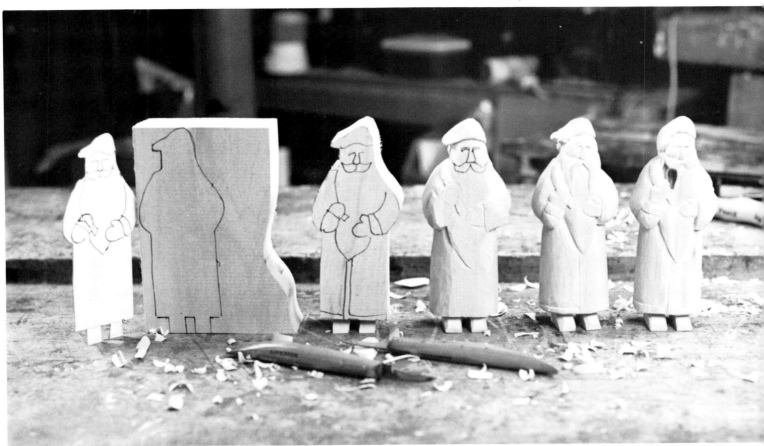

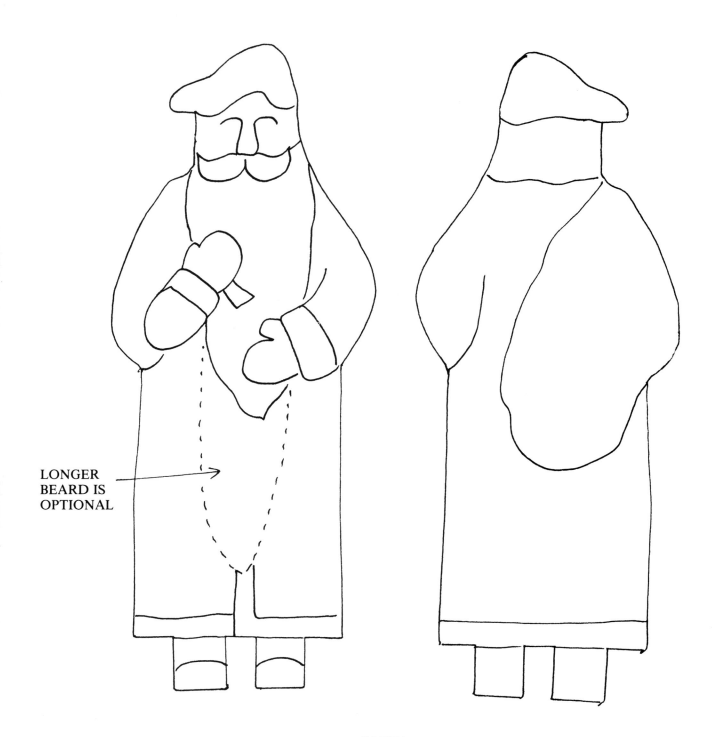

LONGER
BEARD IS
OPTIONAL

SANTA #3

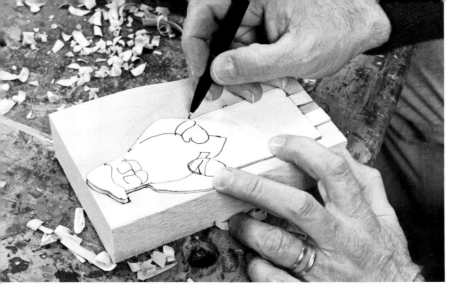

TRACE THE PATTERN FOR SANTA #3. I LIKE THE BLACK FELT TIP. I CAN SEE THE LINES AND YOU WILL CUT THEM OFF SOON ANYWAY.

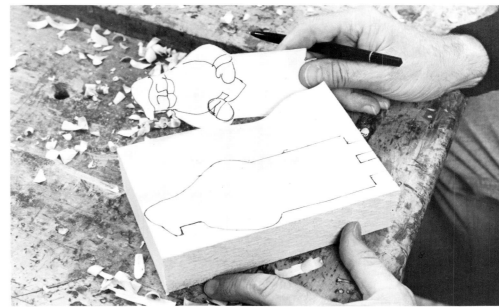

TAKE A GOOD LOOK AT YOUR PATTERN, YOU DON'T HAVE TO DECIDE NOW, BUT LOOK AT THE COLOR PAGES. YOU MAY WANT TO DO A LONGER BEARD.

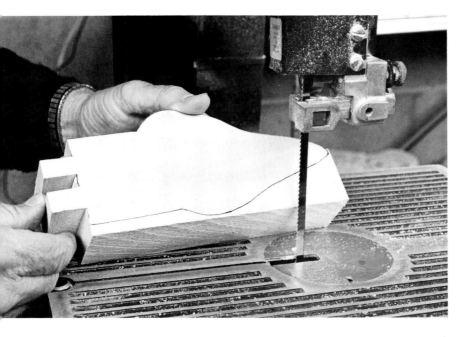

NOTICE AGAIN THE FLAT SIDE WHICH WILL BE NEXT TO THE LAST AREA CUT OFF. REMEMBER THIS IS TO MAKE CUTTING THE FEET EASIER.

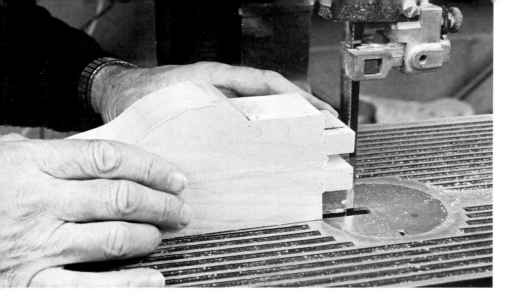

YOU CAN SEE IT IS EASIER TO CUT
SINCE YOU'VE LEFT ONE SIDE FLAT.

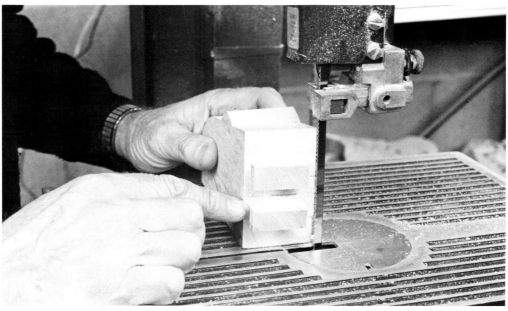

YOU CAN CARVE OUT THE FEET,
BUT THE SAW IS QUICKER.

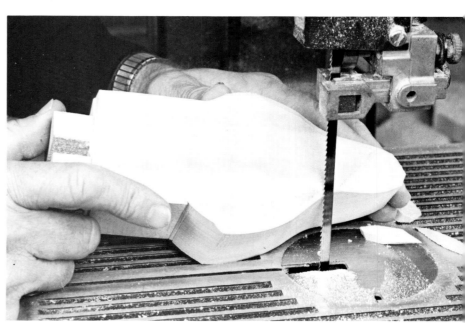

TRIM THE EDGES VERY
CAREFULLY. AGAIN, THIS IS SIMPLY
TO SAVE TIME AND YOU CAN TAKE
OFF THE EDGES WITH YOUR KNIFE.

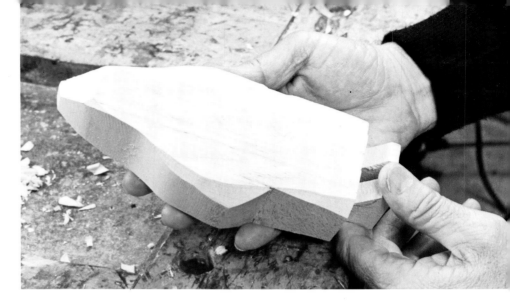

THIS IS SANTA #2 BUT, OTHER THAN THE BERET, YOUR SANTA SHOULD LOOK SOMETHING LIKE THIS IF YOU TRIMMED THE EDGES WITH THE SAW.

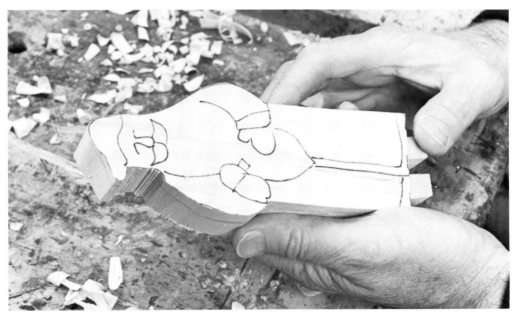

IF YOU DIDN'T, THEN YOU ARE READY TO START CARVING.

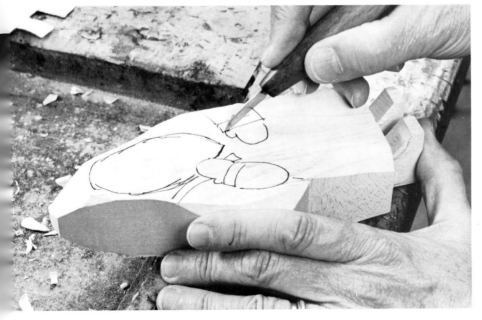

INCISE ALL THE DRAWN LINES JUST AS YOU HAVE YOUR OTHER TWO SANTAS.

YOU MAY WANT TO INCISE A LITTLE DEEPER. YOU ARE GOING TO DETAIL MORE ON SANTA #3.

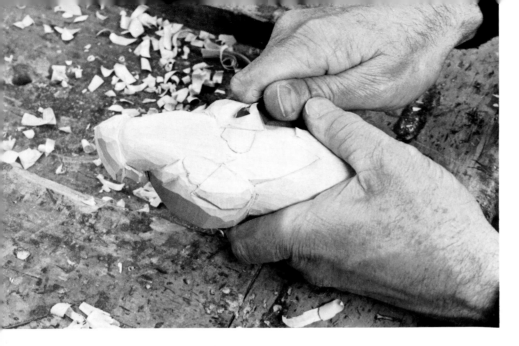

NOTICE I HAVE DEFINED THE BERET AND HAVE BEGUN TO SHAPE THE FACE AND ARMS. I HOPE BY NOW YOU HAVE MASTERED THE USE OF YOUR THUMB.

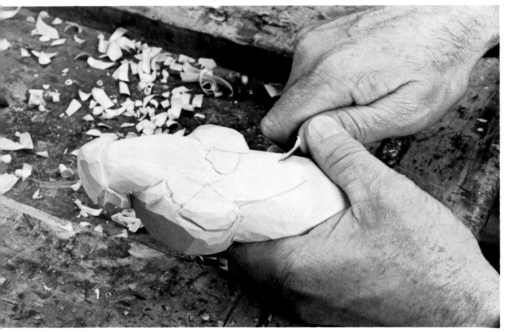

I HAVE OPTED FOR THE LONGER BEARD. AFTER YOU HAVE INCISED THE LINE, LAY YOUR KNIFE ALMOST FLAT AND BEGIN CUTTING TO YOUR INCISED LINE.

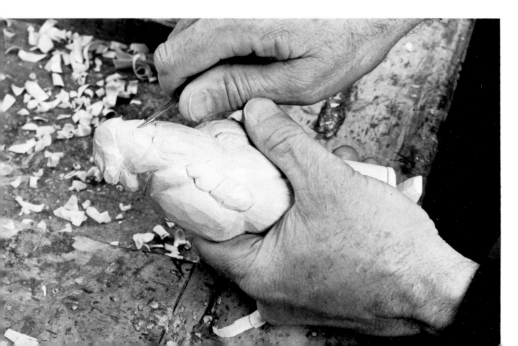

MOST PEOPLE WHO BUY MY SANTAS LOOK AT THE FACE AND BEARD.
SPEND MOST OF YOUR TIME ON THE FACE. YOU MAY WANT TO LOOK AT THE COLOR PHOTOS OF THIS SANTA TO SEE THE DIFFERENT STYLES I'VE DONE FROM THE SAME PATTERN.

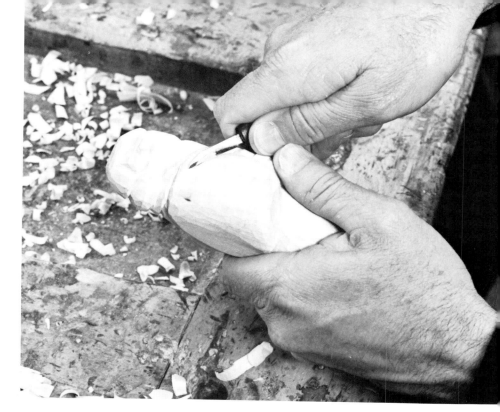

CONTINUE TO ROUND OFF THE
BODY AND AROUND THE BAG.
DON'T LEAVE ANY SHARP EDGES.

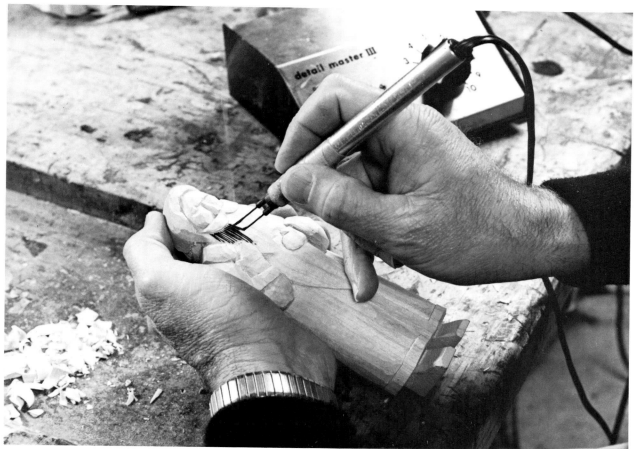

I HAVE CHOSEN TO BURN BEARD DETAIL INTO THE SANTA. THE
DETAIL MASTER IS GOOD BUT YOU CAN GET THE SAME EFFECT
WITH ONE OF THE LESS EXPENSIVE MODELS.

# PAINTING INSTRUCTIONS

Painting instructions are included for the following Santas.

Santa #1

Santa #2

Santa #3

Father Christmas

Weathervane Santa

Santa pins

Victorian Santa

and many others

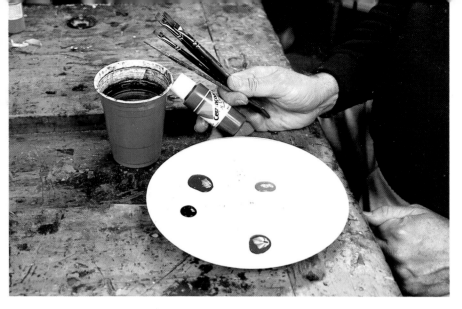

TO PAINT YOUR SANTAS YOU WILL NEED ACRYLIC PAINT AVAILABLE AT MOST CRAFT AND HOBBY SHOPS. I USE CERAMCOAT BY DELTA BECAUSE I'VE HAD GOOD LUCK WITH IT. YOU WILL NEED A PAPER PLATE WITH COMPARTMENTS. I PREFER STYROFOAM.

YOU WILL SEE THAT I PAINT SANTAS VARIOUS COLORS. FOR YOUR BASIC SANTA YOU WILL NEED RED, GREEN, BLACK, WHITE AND SOME SKIN COLOR.
 I PREFER A LIGHT SKIN COLOR DUE TO THE FACT IT TAKES ANTIQUING BETTER. WATER OF COURSE AND A #8, #10 AND ½-INCH BRUSH.

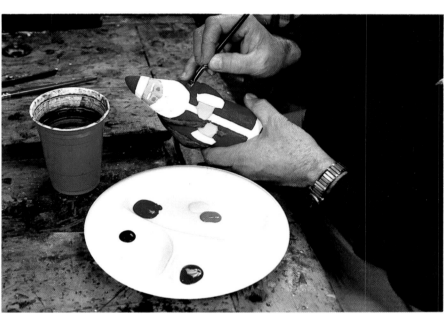

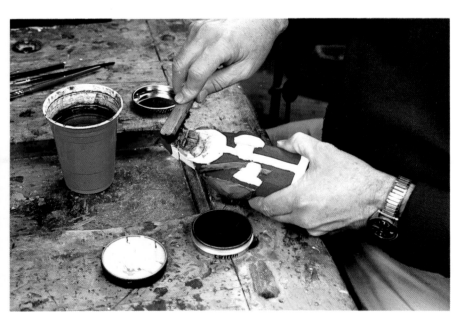

AFTER THE PAINTING IS FINISHED YOU MAY WANT TO ENCOURAGE DRYING WITH A HAIRDRYER.
 AFTER THE COLORS DRY, I ANTIQUE WITH BARK BROWN SHOE POLISH FROM GRIFFIN. OTHER SHOE POLISH WILL GIVE YOUR SANTA A PURPLE TINT.

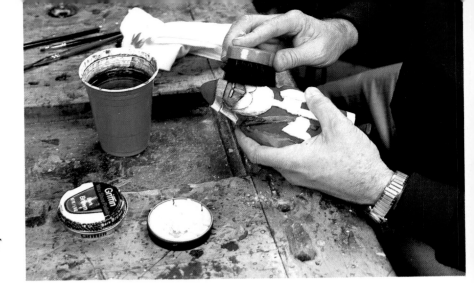

AFTER COMPLETELY COVERING
THE SANTA WITH SHOE POLISH, LET
DRY. THEN, USING A SOFT SHOE
BRUSH, POLISH.

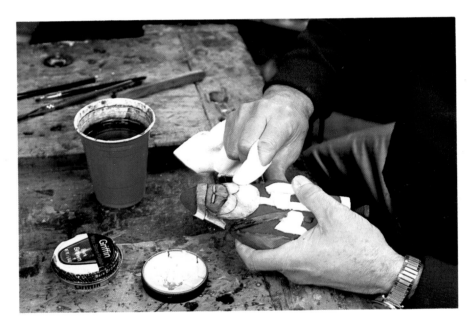

WITH THE NEUTRAL POLISH RUB
OFF SOME OF THE BROWN. I USE
AN OLD T-SHIRT BUT ANY SOFT
CLOTH WILL DO. CONCENTRATE
ON THE SKIN AND WHITE AREAS.
ENOUGH BROWN WILL REMAIN TO
GIVE THAT SOFT, ANTIQUE LOOK.
    THERE ARE A GREAT NUMBER OF
ANTIQUING PRODUCTS ON THE
MARKET YOU MAY WANT TO TRY
ONE OF THOSE.

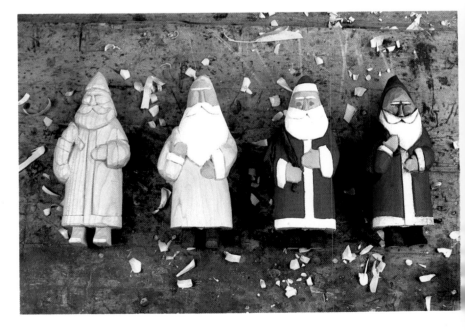

YOU MAY HAVE NOTICED I NEVER
USED SANDPAPER. I WANT MINE TO
LOOK OLD AND NOT PLASTIC. THIS
PHOTO SHOWS THE VARIOUS
STAGES OF PAINTING.

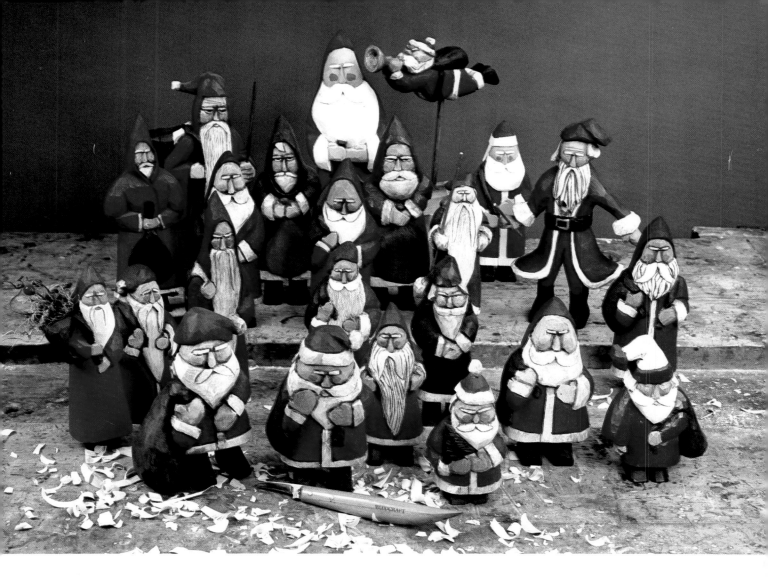

THIS IS MY SANTA FAMILY. ON THE NEXT FEW PAGES ARE THE
THREE I'VE TRIED TO HELP YOU WITH PLUS A FEW OTHERS. THEY
ARE THE SIZE I CARVED THEM OR FAIRLY CLOSE. I HAVE GOTTEN
IDEAS FROM MANY SOURCES, BUT WHO IS TO SAY WHETHER
YOURS OR MINE ARE CORRECT? THIS IS PART OF THE FUN OF
CARVING SANTAS. I'VE TRIED TO CREATE MY OWN STYLE AND I
HOPE YOU WILL TOO. YOU WILL NOTICE THAT I SELDOM ADD
EYES BUT LET THE ANTIQUING GIVE THE LOOK OF EYES IN THE
SHADOW. IF YOU PAINT IN EYES A SIMPLE DOT OF BLACK AND A
LITTLE WHITE SHOULD DO.

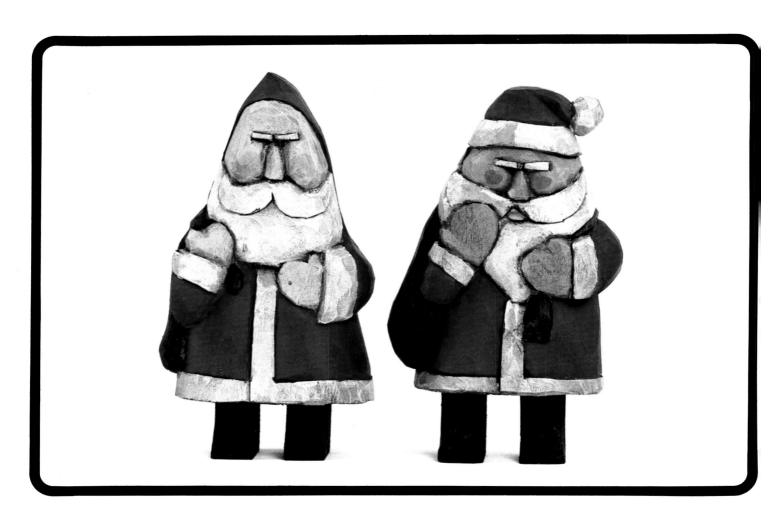

THIS IS SANTA #1. THE ONE ON THE LEFT IS JUST LIKE THE FIRST
ONE IN THE BOOK. THE ONLY DIFFERENCE IN THE ONE ON THE
RIGHT IS THE BEARD, PLACEMENT OF HANDS AND THE CAP. (6”
high, 7” wide)

THIS IS SANTA #2. NOTICE THE DIFFERENT BEARD AND
MOUSTACHE TREATMENT. ALSO, LOOK AT THE MIDDLE SANTA.
OTHER THAN NOT BEING ANTIQUED HIS RIGHT HAND IS LOWER.
(7¾" high, 9½" wide)

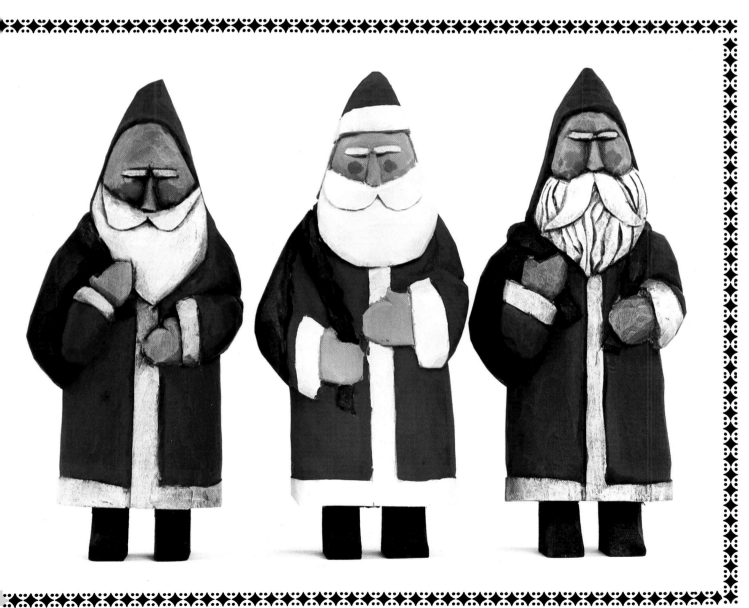

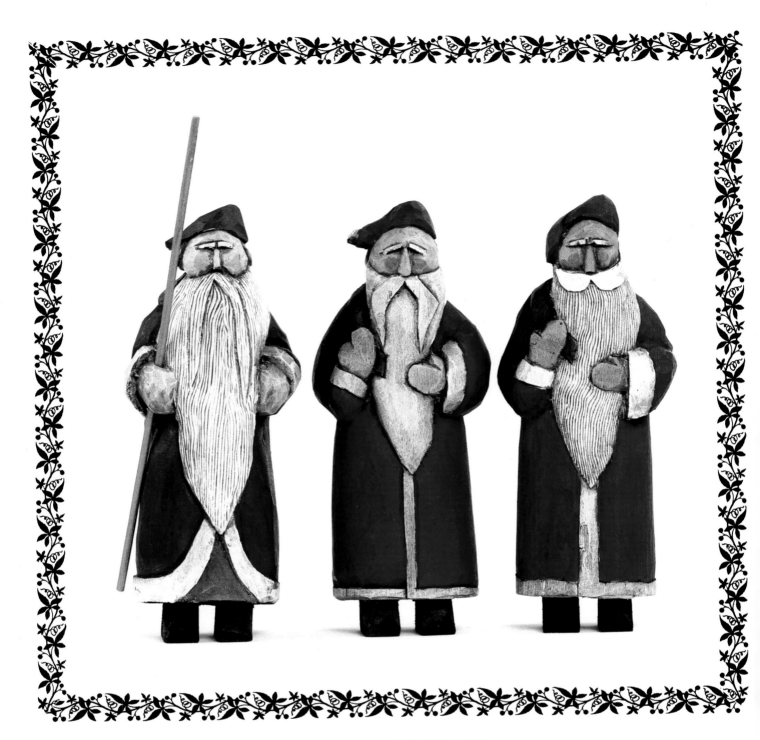

THIS IS PATTERN #3. EACH IS DONE A LITTLE DIFFERENTLY. THE LEFT ONE HAS HIS HANDS IN A LITTLE DIFFERENT MANNER ALSO THE BOTTOM OF THE ROBE IS DIFFERENT. HE IS ALSO PURPLE AND HAS A SHAFT. THE DIFFERENCE IN THE MIDDLE SANTA IS THE BALL ON THE HAT. THE SANTA ON THE RIGHT HAS AN UPTURNED MOUSTACHE. HE AND THE ONE ON THE LEFT HAVE WOOD BURNED BEARDS. (7" high, 8½" wide)

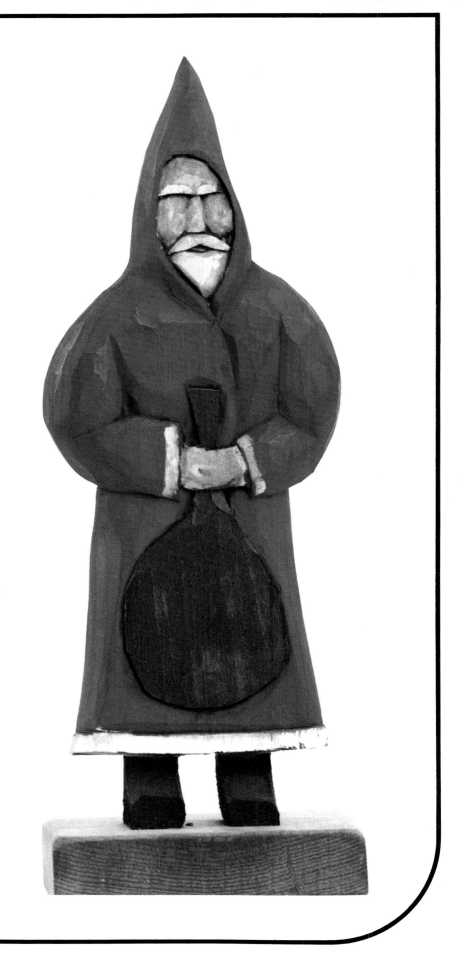

THIS IS MY FIRST FATHER
CHRISTMAS. HE GOT ME INTO
SANTA CARVING. (9½" tall, 3¼" wide.
Base is 3⅜" wide)

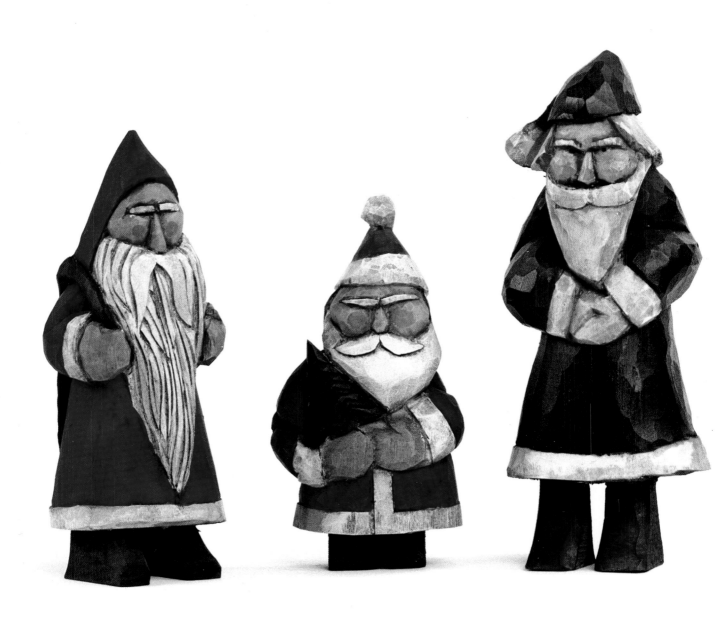

THE SANTA ON THE LEFT IS A POPULAR SIZE. NOTICE THE
DIFFERENT BEARD TREATMENT I INCISED AND THEN CUT AWAY.
THE MIDDLE SANTA HAS A TREE CARVED INTO THE BODY.
REMEMBER ANYTIME YOU ADD SOMETHING IT WILL TAKE MORE
TIME AND TIME IS MONEY.
    THE SANTA ON THE RIGHT IS GREEN AND ONE OF MY EARLY
ONES. HE'S TOO SQUARE AND HIS FACE IS TOO FLAT. (1.) 6" high, 2¼"
wide; (2.) 4½" high, 2½" wide; (3.) 6⅞" high, 2½" wide)

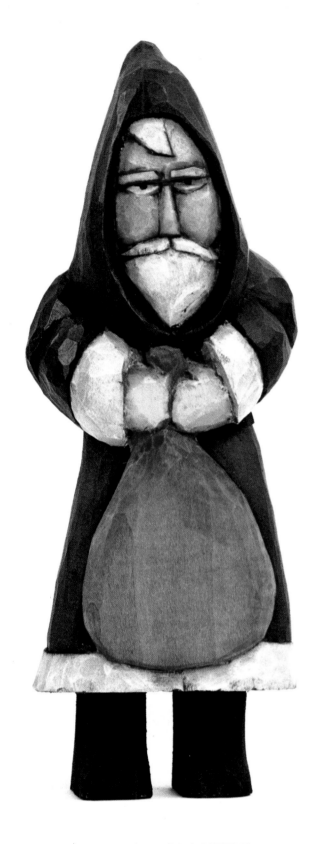

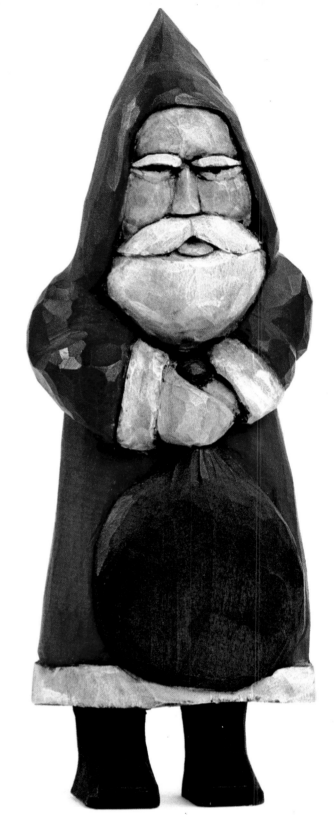

THIS RAKISH RASCAL HAS A LITTLE SHOCK OF WHITE HAIR. I DID THIS AS AN AFTERTHOUGHT. I THOUGHT HIS FOREHEAD WAS TOO LONG WITHOUT IT. HE'S ALSO BLUE. (8⅝" high, 3" wide)

THIS TOO IS AN EARLY MODEL BUT, I'M BEGINNING TO SEE THE IMPORTANCE OF ROUNDING. I EVEN PUT BAGS UNDER HIS EYES. THIS IS ONE OF MY WIFES FAVORITES. I THINK SHE BELIEVES IT LOOKS LIKE ME. (9" high, 3" wide)

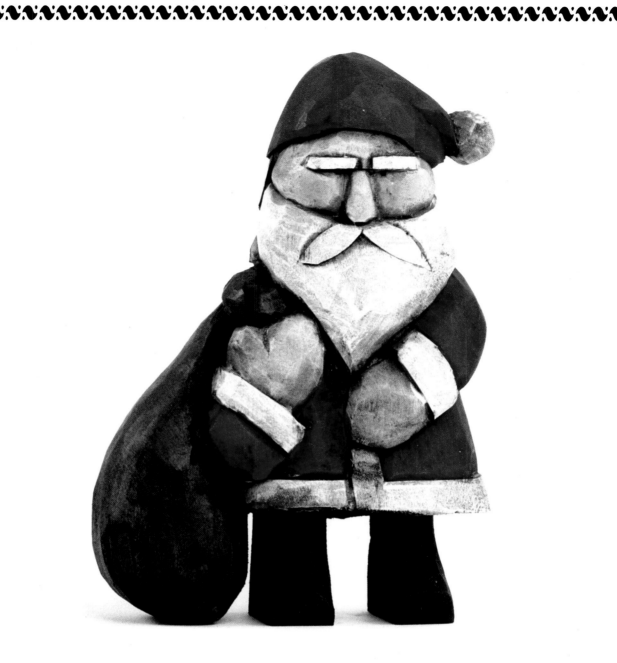

I SUPPOSE HAULING THIS BIG BAG AROUND GIVES THIS SANTA THE
UNHAPPY LOOK. THIS ONE TAKES A LOT OF TIME DUE TO THE
ATTACHED BAG. (6" high, 4¼" wide)

THE WEATHERVANE SANTA IS FUN
TO DO AND IT WILL WORK WITH
THINNER STOCK. YOU CAN CUT
THIS ONE OUT WITH A SABRE SAW.
(8½" high, 7" wide)

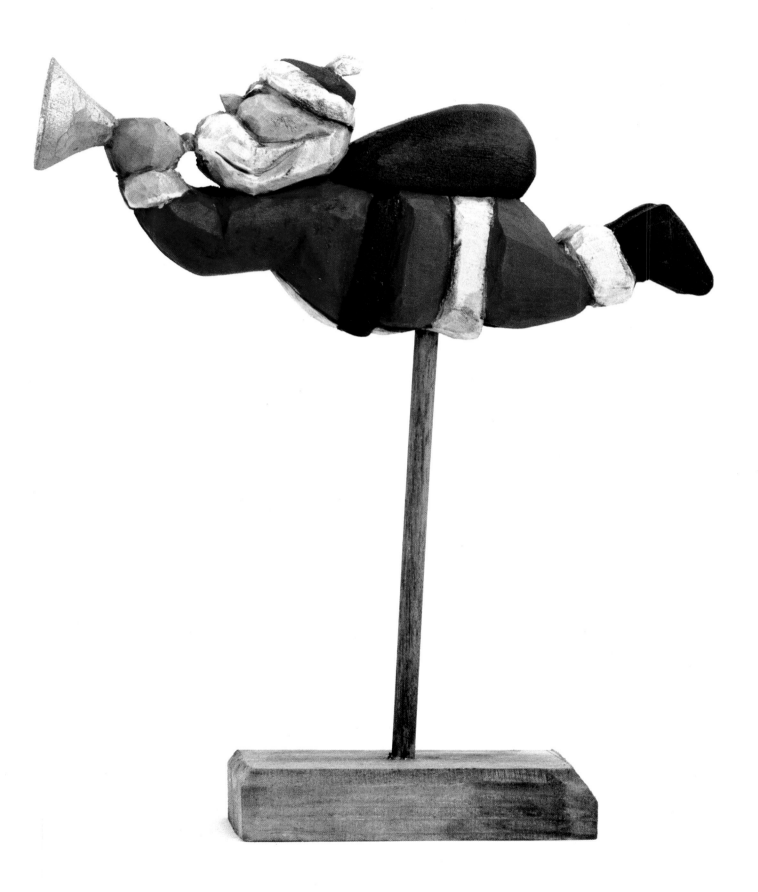

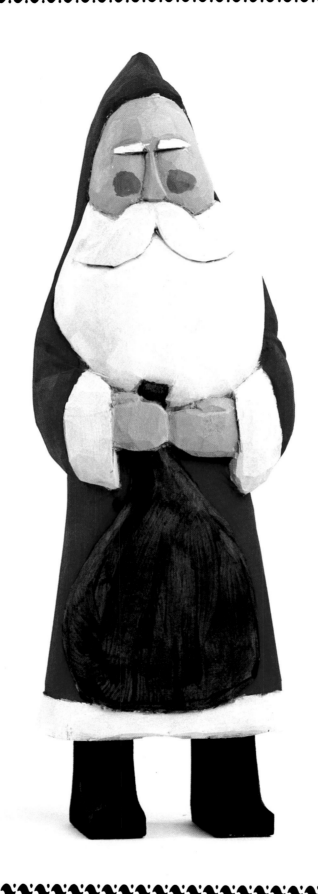

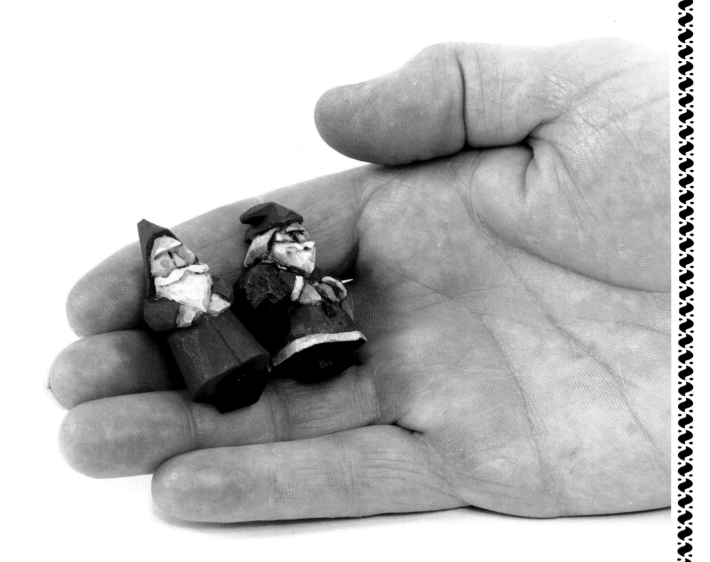

IF YOU DON'T HAVE ENOUGH WOOD FOR A 12" SANTA TRY ONE
OF THESE LITTLE GUYS. THEY MAKE CUTE PINS. A WARNING
THOUGH. THEY TAKE ABOUT AS MUCH TIME AS A BIGGER ONE.
(1⅞" high, ¾" wide)

THIS BIG FELLOW HASN'T BEEN
ANTIQUED. I DON'T PARTICULARLY
LIKE THEM THIS BIG, BUT THIS WAS
A SPECIAL ORDER. (12" high, 4" wide)

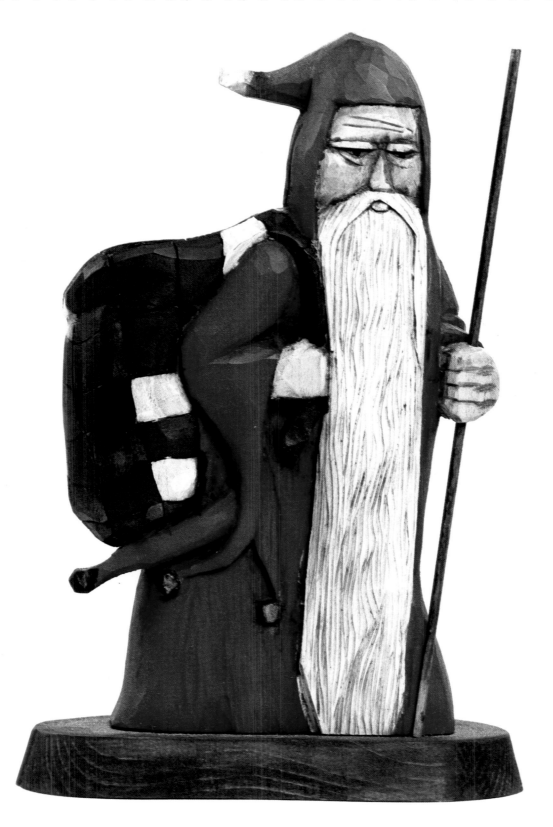

THIS WAS THE FIRST COMPLICATED SANTA I TRIED. HE TAKES A
GREAT DEAL OF TIME AND IS RELATIVELY EXPENSIVE. (10" high, 6"
wide)

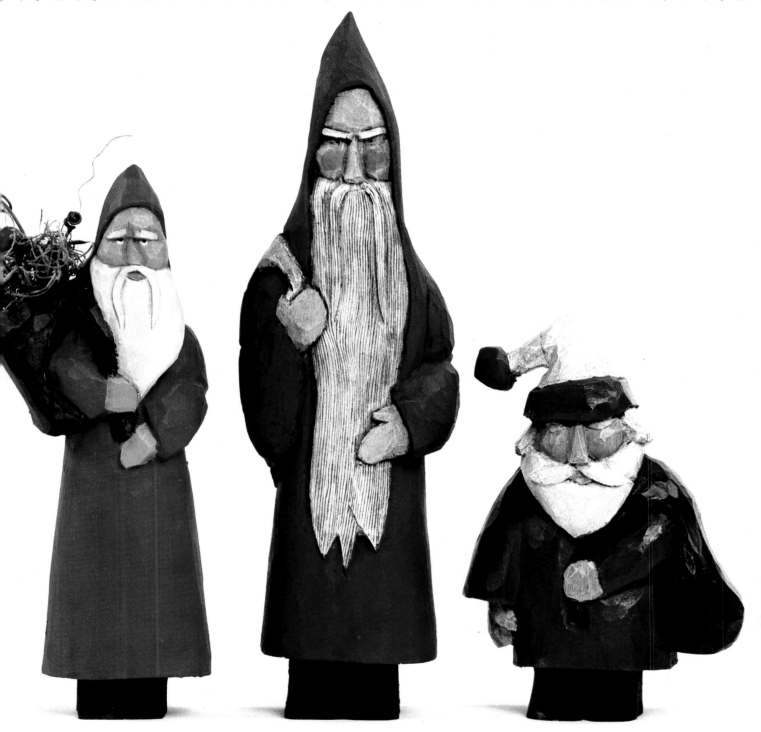

THESE ARE MOLDED FROM MY ORIGINALS. IT IS DIFFICULT TO
TELL THESE FROM THE REAL THING. THEY ARE A GOOD BIT
HEAVIER THAN WOOD. (9" high, 9½" wide)

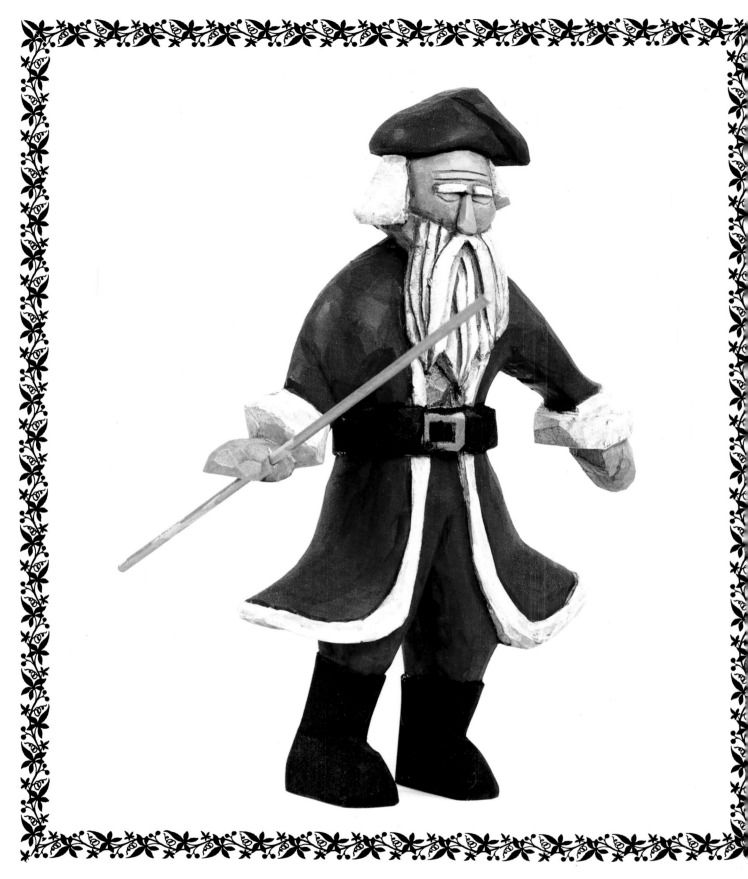

THIS IS MY VICTORIAN SANTA. HE ALSO TAKES A GREAT DEAL OF
TIME. (9½" high, 6¼" wide)